THE OH FUCK MOMENT
—
I WISH I WAS LONELY
by Hannah Jane Walker and Chris Thorpe

THE OH FUCK MOMENT

was first performed at St George's West,
Edinburgh Fringe Festival on 5 August 2011

Written and performed by
Hannah Jane Walker and Chris Thorpe

Visual production by Luke Emery

Executive producer and collaborator Matt Burman

Originally produced by Emily Coleman

Tour produced by Ric Watts and Jenny Gaskell

The Oh Fuck Moment was developed at
The Nightingale Brighton and The Junction Cambridge.

Supported by Arts Council England and Escalator East to Edinburgh.

I WISH I WAS LONELY

was first performed at Forest Fringe,
Edinburgh Fringe Festival on 16 August 2013

Written and performed
by Hannah Jane Walker and Chris Thorpe

Produced by Ric Watts and Jenny Gaskell

Collaborators: Matt Burman, Jason Crouch, Seda Itler,
Ross Sutherland and Francesca Beard

I Wish I Was Lonely was co-commissioned
by ARC, Writers Centre Norwich and Norwich Arts Centre.

Supported by Arts Council England and Escalator East to Edinburgh.

Developed at Cambridge Junction, Warwick Arts Centre,
BIOS and Forest Fringe.

HANNAH JANE WALKER AND CHRIS THORPE

Hannah Jane Walker is a poet. Chris Thorpe is a theatre-maker.

Together we make award-winning work that is part performance, part poetry gig and part interactive experience.

Our shows take place in rooms. Sometimes those rooms are theatres, but often they're offices, meeting rooms, cafes – anywhere that people can come together.

Our work is based around an honest encounter between ourselves, an audience and the difficult but often uplifting moments we all face in the process of living.

Our shows feel like a generous, open conversation, with poetry and storytelling at their heart and space for audiences to contribute in a meaningful way.

We first collaborated on Hannah's solo show *This Is Just To Say* in 2010 at Forest Fringe.

We then made *The Oh Fuck Moment* in 2011. The show opened in Edinburgh as part of East To Edinburgh and won a Fringe First award.

The Oh Fuck Moment has toured extensively in the UK and internationally, with dates including Roundhouse, Warwick Arts Centre, The Junction, Norfolk and Norwich Festival, PULSE Festival, Sheffield Theatres, Soho Theatre, The Lowry, Dublin Fringe Festival, Belfast Festival and Tig7 in Mannheim Germany.

The show has also been translated into Greek with a production in 2012 at BIOS in Athens.

I Wish I Was Lonely is our third collaboration, premiering at Forest Fringe in 2013, after development across a range of partners, including ARC Stockton Arts Centre, Writers Centre Norwich and Norwich Arts Centre, Warwick Arts Centre, Cambridge Junction and BIOS.

For more information on our work, visit:
www.hannahjanewalker.co.uk

Chris Thorpe is a writer and performer from Manchester. He is a core member of Unlimited Theatre, and was a founder member, collaborating on all but two productions. He's also an artistic associate of Third Angel. As a solo performer, he is making a cycle of pieces for publication and performance which he performs at festivals in the UK and abroad. He also continues to collaborate with companies like Slung Low, Forest Fringe (he curated part of their season at the Gate in 2012 and has worked with Forest since its inception in 2006) RashDash, and Soup Collective, with whom he wrote and recorded the piece *The Bomb On Mutannabbi Street Is Still Exploding*, which has been permanently installed at the Imperial War Museum North. Chris's plays have been produced worldwide and he has toured with Unlimited and Third Angel in Europe, Africa, Asia and the USA. Recent projects include *Overdrama* for Portuguese company mala voadora, which opened at Culturgest Lisbon, in July 2012, two new plays for BBC Radio, the first of which, *Rio Story*, was a Radio 4 Friday night play in 2012, and a modern version of *Robin Hood* in verse for the NSDF Ensemble/ Latitude Festival. He is developing new work with Unlimited and Third Angel, and is touring in Third Angel's show *What I Heard About The World* into 2013/4 when the show will be touring in France, Poland and Brazil, and play as part

of the British Council showcase 2013 at the Edinburgh Fringe. His play, *House/Garden* opened at the Centro Culturel do Belem in Lisbon in 2012 and is currently touring to France. *Dead End*, his next show for mala voadora opened at the European Capital of Culture in Guimaraes, 2012 and then ran in Lisbon and will be touring in 2013/14. *Overdrama*, *House/Garden* and *Dead End* form a loose trilogy of plays for mala voadora which will be published in Portuguese in late 2013.

He worked with poet Hannah Jane Walker in 2010 to make her solo show *This Is Just To Say*. Hannah and Chris then worked together again to create *The Oh Fuck Moment*, which won a Fringe First at Edinburgh Fringe 2011 and will be touring sporadically over the next couple of years. Chris is developing a new piece at the West Yorkshire Playhouse with Belarus Free Theatre, who he worked with on the English version of their recent show *Minsk, 2011*. He also plays guitar in Lucy Ellinson's political extreme noise project TORYCORE, and is a selector for the National Student Drama Festival.

Right now Chris is making a new show, *I Wish I Was Lonely* with Hannah Jane Walker: and is co-writing *The Noise* for Unlimited Theatre and Northern Stage, opening in Autumn 2013. He has recently finished a commission for the Royal Exchange in Manchester, *(There Has Possibly) Been An Incident*, which opens at Latitude/ Edinburgh 2013 and then tours

after a run in Manchester; and a godless version of *Faust* for children called *Hannah*, which opens at the Unicorn Theatre in early 2014. He's working on a new solo piece, *Confirmation*, with Warwick Arts Centre and Rachel Chavkin of the US company the TEAM; and is also writing *Dark Woods, Deep Snow*, the 2013 Christmas show for Space One at Northern Stage.

In 2013 Oberon Books will publish two separate volumes of Chris's work – one including *The Oh Fuck Moment* and *I Wish I Was Lonely*, his pieces with Hannah Jane Walker, and *(There Has Possibly) Been An Incident*.

Hannah Walker is a poet from Cambridge and Essex. She studied literature at the University of East Anglia and poetry at Newcastle University. She has performed all over the UK and abroad, most recently Australia and Germany. She has started to make theatre, namely off a stage, starting with her solo show *This Is Just To Say*. The second show, a collaboration with Chris Thorpe – *The Oh Fuck Moment* – was awarded a Fringe First 2011. She also works as an arts project manager, having worked in the education team at the Norfolk & Norwich Festival and currently working for live literature development organisation Apples and Snakes. Hannah runs writing workshops in schools and community groups and programmes poetry events. A pamphlet of performance pieces was published by Nasty Little Press 2010http://www.nastylittlepress. org/people/hannah-jane-walker/. Her poems are full of sharp edges and unexpected angles as well as warmth and empathy for her fellow humans. They are funny and they're simple and they're complicated and they don't know right from wrong sometimes.

Ric Watts is Producer for Unlimited Theatre, based at West Yorkshire Playhouse in Leeds. Shows produced for Unlimited include *Mission To Mars, The Giant & The Bear, MONEY the game show* and *The Noise*. He is also Producer for Analogue (*Mile End, Beachy Head, 2401 Objects, Lecture Notes on a Death Scene*); and Chris Goode & Company (*The Adventures of Wound Man and Shirley, 9, GOD/HEAD, Monkey Bars, The Forest & The Field*); and is producing *The Oh Fuck Moment* and *I Wish I Was Lonely* with Hannah Jane Walker and Chris Thorpe. Ric started his career as Producer at Your Imagination, where he produced work by Cartoon de Salvo, Ridiculusmus and Kazuko Hohki. Since 2006, he has produced and toured work by theimaginarybody, The TEAM, Filter and Schtanhaus, The Frequency D'ici, Starving Artists, Laura Mugridge, Royal & Derngate, The Other Way Works, Slung Low and the Queer Up North International Festival. He is currently on the board of Cartoon de Salvo, the advisory boards for RashDash and DEP Arts, and sits on the Large Arts Awards Committee for the Wellcome Trust.

Jenny Gaskell is an independent producer & maker. She currently produces for The Future – an artist-centred development collective currently supporting the work of Façade Theatre, Massive Owl, Lowri Evans, Leentje Van De Cruys, Nicki Hobday and Sara Crocker. She is responsible for the Lancashire county touring projects for Live at LICA, which is currently touring work by Quarantine and Talking Birds. Jenny produced and toured *My Heart Is Hitchhiking Down Peachtree Street* by J.Fergus Evans at Contact, CPT, Pulse Festival and others; and works with Hannah Jane Walker and Chris Thorpe on their shows *The Oh Fuck Moment* and *I Wish I Was Lonely*. She is also a co-founder and producer of the Lost & Found Festival in Manchester and created the project *100 Deeds* investigating modern-day feminist action and *Making it Happen*.

CRITICAL ACCLAIM FOR THE OH FUCK MOMENT

This is a quietly profound piece; and its central message – that to mess up is human, and should be embraced and learnt from rather than damned – is generously suggested, not forced down your throat.
Whatsonstage.com
★★★★

This is an uneasily entertaining afternoon of reflection on human frailty that teaches us not to beat ourselves up too much, and no doubt provokes further anecdotes afterwards from an audience who are encouraged to fess up to their social toe-curlers.
The List
★★★★

This remarkable piece of participatory theatre ranks as among the most absorbing and thought-provoking.
Telegraph
★★★★

Chris and Hannah are so laid back it's easy to believe they are simply having a chat with us, rather than delivering what is actually a cleverly constructed piece of work. Its final words are a mantra for the stressed-out idealist within us all. None of us are perfect; we are all just f**k-ups who occasionally achieve perfection.
Scotsman
★★★★

A neatly constructed, clever and strangely poignant mix of poetry and performance. All of us have had those moments when we say or do something that seems completely irrevocable, for which no apology will ever be enough. But where do those moments come from? **With wit and poetry, *The Oh Fuck Moment* explores these ideas in a uniquely constructed show that feels like a strangely intimate office meeting, a performance lecture and a tea party**.
Guardian
★★★★

A NOTE FROM THE WRITERS

These aren't playscripts. While the language of the poems is fixed, the tone of the poems is conversational. The interactions with the audience and the stories change and evolve from performance to performance, depending on the unique mix of people in the room. These shows are conversations – they're different every time they happen. So these scripts aren't a faithful record or an instruction manual. Rather they're an attempt to represent the experience of these shows in printed form – a framework that hopefully allows space for the range of things that might have happened, and might happen in the future.

Hannah Jane Walker and Chris Thorpe

THE OH FUCK MOMENT

methuen | drama

LONDON • NEW YORK • OXFORD • NEW DELHI • SYDNEY

METHUEN DRAMA

Bloomsbury Publishing Plc

50 Bedford Square, London, WC1B 3DP, UK

1385 Broadway, New York, NY 10018, USA

29 Earlsfort Terrace, Dublin 2, Ireland

BLOOMSBURY, METHUEN DRAMA and the Methuen Drama logo are
trademarks of Bloomsbury Publishing Plc

First published in Great Britain by Oberon Books 2013
This edition published by Methuen Drama 2021

Cover images: Martin Figura

A catalogue record for this book is available from the British Library.

ISBN: PB: 978-1-3502-6259-1
eBook: 978-1-7831-9531-2

Printed and bound in Great Britain

To find out more about our authors and books visit www.bloomsbury.com
and sign up for our newsletters.

Space set up –

*Disused or currently in-use office space or a room in a theatre which can be
made to look like an office. Not a black box theatre space. No stage lights.
Preferable – strip lights used in offices.*
*The room is untidy and not in good condition – looks like people have got
up and just gone. Tables set up conference-style in the middle of the room.
25 chairs for the audience around the table. A chair each for CHRIS and
HANNAH. In front of each audience seat on the table, one post-it note and a
pencil and a permanent marker.*
*Set up in corner – laptop and speakers for playing of song mid-way through
show. Hockey stick hidden somewhere in the room.*

*Stuck on walls – pictures of office Christmas parties and health and safety
notices and any other office-related paperwork.*

*The table covered with screwed-up pieces of paper and a large toy plane and
office files and pens and pencils and staplers and broken computer keyboards,
etc.*

*By the door – a table set up with a tea urn on it and a mug for each audience
member and HANNAH and CHRIS.*

27 mugs in total.
On the bottom of 5 of them is a dot drawn in permanent marker.
On the bottom of 4 of them is a cross drawn in permanent marker.
On the bottom of 1 of them is the name DON written in permanent marker.
On the bottom of 1 of them is the name PETE written in permanent marker.

*The mugs are mixed up on the table randomly and given to each audience
member as they come through the door.*

*Costume/clothes – HANNAH and CHRIS both wear badly fitting office suits.
Both have a lanyard around their neck saying HUMAN RESOURCES.*

*Audience assemble at a central meeting place outside of the room or by the
venue box office. CHRIS comes out to meet them and says something like –*

C: Hello. Don't worry. I'm not acting. We haven't started yet.
 Has everyone turned their phone off? Great. Let's go and get
 a cup of tea.

Audience follow CHRIS through to the room and holds the door open for the first few. As they come in HANNAH gives them a cup of tea and tells them to take a seat.

Once everyone is sitting down – HANNAH and CHRIS, still standing up, read in turns from a set of cue cards in their hands. During next bit of script – both sit down in their place at the table at different moments whenever feels right.

C: A man wakes up on an airbed with no land in sight.

H: A poker player with four Kings stares down the barrel of four Aces.

C: A violinist stops on the street, visualising her instrument on the back seat of a taxi.

H: Two teenage boys realise too late, that the gun was loaded after all.

C: A family get off the train and soldiers and barbed wire fences.

H: A zoo keeper hears heavy breathing in the cage she thought was empty.

C: A man puts down an empty shot glass and feels his heart skip its first ever beat.

H: A midwife wakes in a cold sweat realising that she's tagged the babies wrong.

C: A chemistry student realises why it's a bad idea to drink liquid nitrogen for a bet.

C: A phone rings in the execution chamber a minute after the switch is flipped.

H: A man slams his laptop shut just that crucial second too late.

C: A woman wakes and realises that dream she just had about drunken sex was not in fact a dream.

H: An S&M enthusiast realises he has forgotten the safe word.

C: A surgeon misreads 'Circumcision' as 'Castration'.

H: The president realises that the mic was on after all.

C: A parachutist looks up to see the reserve chute tangled in the main chute that she has just cut away.

H: I used to work in an office.
More specifically, I used to work for a marketing company called Fox Murphy, in Norwich.

One of the good things, I guess,
was that everyone seemed to have something outside work.
I mean they weren't making fusion reactors in their sheds or homemade porn or anything but some of them were really into skiing, or playing the tuba
and there was this one woman, she was about five years older than me, and her thing was riding, horse riding.
Her name was Emma.
She probably does still have horses.
Emma used to finish her working day, and go straight to the stables because she used to have a number of complicated things that she needed to do with the horses, you know, maintenance and stuff to make sure their legs didn't fall off.
And the reason I know this, is that Emma liked to talk about her horses.
She liked to talk about her horses a lot,
in a voice that is just like a radio that's just slipped off its station,
in the open-plan office, where we all worked.

She could throw the word 'dressage' across the room like an ice-pick to the ear.
I don't want to give you the impression that I'm totally unreasonable.
I wasn't the only one who got annoyed by it,
my mate Kat used to send me one-word emails that just said 'neigh'.
Mostly it was fine though, I got on, I ignored it, talked to Emma by the microwave, I once bought her a birthday card with a picture of some stables on it.
But one day, it got really bad.
It got so bad that I felt like she was basically standing right next to my desk and screaming the word HORSE into my ear every two or three seconds.

So I sent this email to Kat.
And the email was very short.
It just said: 'If she doesn't stop talking about that horse,
I am going to blind it, cut its fucking head off and leave the
head in her bed.'
It was basically just a bit of a tension reliever.
I've got no idea how you'd actually go about cutting a horse's
head off.
But of course, I sent the email to Emma by mistake.
It took me about ten seconds to realise what I'd done,
two seconds to completely shit myself,
and about three more seconds to come up with this plan.
I rang Kat at her desk, and I asked her to distract Emma,
basically to come up with any sort of reason to get Emma to
leave her computer for a minute or two.
And I casually walked over, ducked down next to her
computer
and her email browser was open, which was good.
Except it wasn't because I could see my email in it
and it was already marked as 'read'.

Basically, I sent a really horrible email.
A really offensive email.
As a joke.
To relieve some stress, but still a really horrible email about
doing something hideously violent to the thing a blameless if
annoying person loved most in the world – and because they
read that email I put that image in their head,
simultaneously hurt their feelings and probably made them
think they were working with a psychopathic horse-fucker.
Things really couldn't get any worse.
Except it *could* get worse, obviously.
Because when I stood up to leave,
Emma was just standing there at the entrance to her cubicle.
Just looking at me.
Any normal person would have said sorry.
But not me.
What I did was
I leapt at Emma.
Physically, I levitated through the space between us,

and for no reason that I can explain I wrapped my arms and
legs around her
and I just hung there for dear life.
So I was there.
With my arms and legs wrapped around Emma,
and she hadn't said anything.

And I realised, I was going to have to let go
at least so she wouldn't have to go home with me wrapped
around her
like a panicky starfish.
So slowly I put my feet back down on the ground.
and I stepped back
and I looked Emma right in the eye
and I opened my mouth
and I realised I was going to say sorry.
I'm not quite sure what I was going to say sorry for first:
threatening to kill her horse, reading her inbox, probably
contrary to the Data Protection Act, or, physically assaulting
her in the workplace.
So I stood there, with my mouth open, just looking at her.
And I realised there wasn't any apologising for what I'd done.
And there wasn't any way back.
And the first words out of my mouth.
In fact the only words for quite a while, were 'oh fuck'.
And I don't work for Fox Murphy anymore…

C: But that is the definition of an oh fuck moment.

H: So er, Hi.

C: Hello

A moment where HANNAH and CHRIS make eye contact with every
audience member.

H: In the next hour, we are going to ask you to do some things.
 We are going to ask you to write something down.
 We might ask you to read something out.
 It's not going to be anything more strenuous than that.
 We're not going to ask you to act or dance or sing.
 And just to reassure you, we're not going to repeat anything
 that you might choose to tell us outside of this room,

and we are not going to take the piss out of you.
because whatever you've done,
we've probably done something that's worse.
And if we ask you to do something, and it makes you feel
really uncomfortable,
just don't do it. It's really not a problem at all.

This show is penance for our past mistakes,
we'd like to reassure you,

C: we'd like to reassure you,

H: that we haven't killed anyone.

C: Or at least I haven't.

H: There was that incident

C: yes, there was that incident
when I was asked to give a lecture on the design parameters
for nuclear reactors
to the Japanese Ministry of Public Safety,
and was forced to extemporise because I'd left the laptop at
the airport.
Then there was that other thing,

H: yes there was that other thing.
My thumb misfired while texting drunk,
I asked the boss round to have oily sex
made worse by the fact he texted back
to ask what time he should come over –
that made for some awkward meetings.

C: Almost as awkward as the time
I overheard you tell your best mate, I was a fucking dick.
Now I'll admit, a fucking dick is what I'd been.
but once you'd said it, we were in the cul-de-sac of fact.

H: There's no way to change mincemeat back to flesh
or reverse-suck soundwaves to your mouth.

C: The ink was in the skin.
The cogs of clocks won't stop, and sorry soap just won't get
deep enough

H: when boyfriends have been fucked, or emails sent to wrong
 recipients

C: or you've switched the blender on someone else's fingers.

H: Right, this is the first, well actually the only time we are going
 to ask all of you to do something together. You will see in
 front of you there is a pen and a post-it note. And what we'd
 like you to do, is to think of an oh fuck moment, something
 that you personally have done, and we'd like you to write it
 down on your post-it note, in one or two sentences.
 It could be something tiny, or it could be something massive.
 The only criteria is whether you said it or not you said it at
 the time,
 the only appropriate response to what you had done was to
 want to say 'oh fuck'.

 Two things, don't put your names on them.
 And secondly, if we could all start them the same way,
 if we could all start them with the words
 'it was when, I...'
 And I'll just write that up on the flipchart.

HANNAH writes this up on the flipchart.

C: While we're doing that, I'm going to put a song on for us to
 listen to. It's about two and a half minutes long. But if you
 finish writing before the song finishes, don't just sit there in
 silence. Talk to your neighbours if you want. Get to know
 them, if you don't know them already.

CHRIS presses play on the laptop.

The song is 'The Wedding Present – Back for Good'.

CHRIS says, whilst the song is playing:

C: Now there is this thing that psychologists call option paralysis,
 and
 it's when the number of possible solutions to a task is so huge
 that you go into a kind of catatonic stupor.
 It happens to me sometimes in the cereal aisle of the
 supermarket. The only reason I'm mentioning it right now

is that if it's happening to you, there's no need to worry.
They've even given it a name.

HANNAH and CHRIS make themselves another cup of tea while audience are writing their oh fuck moments. If any audience members are really struggling, HANNAH and/or CHRIS quietly talk to them to see if they can assist.

C: Thank you everyone. You will see that in front of you, you've got a pencil – obviously as you've just been using it – and you've also got a permanent marker and a mug of tea. Could you just have a look under your mug – don't spill any if it's still got tea in it. If you had a black cross on the bottom of your mug, push it forwards so that it stands out in front of you.
Now you four, you lucky, lucky people, have just been randomly selected, by mug, to share your oh fuck moments with the rest of the group.
But we made a promise at the start of the show, that we're not going to force you do anything. So I just want to check – are you OK with doing that?

CHRIS checks in with the people who have the marks on their mugs that they give their consent.

C: Great. We're going to start with you, and we're going to go round clockwise.
The rest of us though, we're not just going to passively absorb the oh fuck moments. Because there's a kind of voting system.
After each person has bravely shared their oh fuck moment with us,
everyone is going to hold up either your permanent marker or your pencil.

If you hold up the pencil it means that you think there is a way back from the oh fuck moment you've just heard.
And if you hold up the permanent marker,
you probably can see where I am going with this,
it means that you think that there is no way back.

Now this isn't a competition and it's not about redemption.
But we are going to take a count,

and Hannah will record the scores on the whiteboard/
flipchart.

*Each audience member with a black cross on the bottom of their mug
reads out their oh fuck moment. And then the audience vote using the
pens and pencils. A score is kept on the board.*

C: So. We've got a range of opinions.
 For the ones where you held up a pencil, those were
 mistakes, amazing mistakes, but there was a way back from it.
 The ones where you held up a permanent marker, those
 were oh fuck moments.
 THIS one, according to the group consensus, there is no way
 back from. *(Read it.)*

H: We seem to think that this one has, most strongly, the main
 characteristic of an oh fuck moment. Which is that once it's
 happened, there's no going back?
 The priceless vase is in a million pieces on the floor or the
 data is written over with random ones and zeroes and your
 opinion of a person, or theirs of you, has changed forever.
 After an oh fuck moment, on some level, the world has
 changed.

C: Donald Rowland killed one hundred and nine people.
 Including himself.
 Fred West killed thirteen people. Including himself.
 So Donald Rowland killed nine times as many people as Fred
 West.
 But you probably haven't heard of Donald Rowland.
 And even if I was to read out the names of every single
 person he killed, you'd probably still rather be stuck in a lift
 with him than with Fred West. Even though he killed all those
 people.

 You might have noticed before, when we looked under the
 mugs, you had 'DON' or 'PETE' written on the bottom of
 your mug. If you've got 'DON' or 'PETE' could you just put
 your hand up?

 Thanks. I'm going to give you these.

CHRIS hands scripts to them.

Don't look at them now – all you need to know is that when I ask you to read, you turn them over. Who's DON? Right. When I ask you to read, you say the lines marked 'DON' and you say the lines marked 'PETE'. I'll say everything in Brackets. Are you both OK with that? Great.

Donald Rowland was the First Officer on a Canadian Airlines flight from Montreal to Toronto Pearson Airport in July 1970. And Donald Rowland crashed the plane.

The Captain, Peter Hamilton, and the First Officer, Donald Rowland, had flown together for years. And they had this ongoing discussion.

Peter Hamilton and Donald Rowland. Just two ordinary guys, talking about house prices and their friends and colleagues. Peter and Donald. Pete and Don. Probably finished each other's sentences like an old married couple.

The ongoing discussion that Pete and Don had was about the best time to arm the spoilers as the plane was touching down. The spoilers are just the big flaps of metal that come up off the wing after a plane touches down – you've probably seen tham. They shouldn't be operated while the plane is in the air, because they make the plane lose all its lift. So as a safety precaution, they have to be armed first. It's a two-stage process. Arm the spoilers, then deploy them.

This next bit's quite complicated.

CHRIS takes a set of cue cards out of his suit pocket and reads the next bit from them. After he has finished each cue card, he throws it over his shoulder.

Normally, if Pete was flying, they did things Pete's way. And vice versa if Don was flying. Pete liked to arm the spoilers on the ground and deploy them straight away. Don liked to arm them just before the plane touched down so that they could be deployed as soon as possible after the plane landed. So because this morning, Pete is flying, as per their agreement, Don should have armed the spoilers just as the wheels touched the runway, and deployed them straight away. Because that's the way Pete liked it. But for some reason, this particular morning, Pete, like an indulgent parent, decided even though he was flying, he'd let Don do the spoiler thing his way. Bear in mind that Don's not used to

22

this. Everything in his body memory is telling him that when Pete's in charge of the actual flying, he arms and deploys the spoilers in one smooth movement when the plane's on the ground. But now Pete's told him he can do it his way, which is to arm the spoilers in the air. But I guess, Don's mind can't quite override the impulse to do what he usually does which is to arm the spoilers and then immediately deploy them, which would be exactly the right thing to do if he was doing things Pete's way, because Pete's flying. In fact Don would never operate the spoilers his own way because they would only get operated that way when Don was flying, so it would be Pete who operated the spoilers when they were doing it Don's way. So despite the fact that Don knows, because Pete's said, that today they're doing it Don's way, his reflex is to do it Pete's way, which is how he usually does it when Pete's flying, so reflexively, and crucially, Don does it at the moment Pete would normally do it if he was doing it Don's way, which is when the plane was still about sixty feet off the ground. And as you remember, the spoilers should never be deployed while the plane's in the air, so what happened was the plane couldn't fly for a second while travelling at about two hundred miles an hour only sixty feet from the ground, and it sounded like this:

The two audience members read their lines from a piece of paper.

DON: Nice day.

PETE: Beautiful.

DON: Those apartments there. See them? The high-rise there. It's quite a good view out over the lake there.

DON: Check three green. Spoilers. When do you want them?

PETE: All right. Give them to me on the flare. I've given up.

DON: Oh yeah?

PETE: I am tired of fighting it.

DON: Well it's pretty late.

PETE: Yeah.

PETE: Okay.

[apparent power reduction.]

PETE: No. No. No.

DON: Sorry, oh sorry, Pete!

[apparent power increase]

[noise of impact]

DON: Sorry Pete!

PETE: Okay. We've lost our power.

[censored language]

PETE: Get the gear up please, Don.

[sound of horn]

DON: What about the flap.

PETE: Flap 25.

DON: Sorry. What was that?

PETE: We've lost number 4 engine.

DON: Have we?

PETE: Is it the fuel? Have we got a fuel leak?

DON: Yes.

PETE: Okay, cut fuel to number 4.

DON: Number 4 engine.

PETE: Yes.

DON: Number 3 engine.

PETE: Number 4?

DON: Number 4, right.

PETE: Number 3 is jammed, too. The whole thing is jammed.

[crackling noise]

DON: What happened there, Peter?

PETE: That's number 4. Something's happened.

DON: Oh, look, we've got a –

[loud sound of explosion]

DON: Pete, sorry.

[louder sound of explosion]

PETE: All right.

[sound of metal tearing]

PETE: We've got an explosion.

DON: Oh look, we've got flames.

DON: Oh, God. We've lost a wing.

[sound of impact. End of transcript]

> Bang. Goodbye Pete. Goodbye Don. Goodbye everyone.
> That's a doozy of an oh fuck moment. As they probably say
> in Canada.
> We're all Donald Rowland, and that's why it's impossible to
> hate him.
> He's just a man who made a small series of arm movements
> at slightly the wrong time. That is all he did.
> Nobody's ever replicated Donald Rowland's oh fuck moment
> either.
> It was learned from. And the way that the spoilers activate on
> planes was changed so that it could never happen again.
> So I guess we give Donald a break. Because to not do that
> would be arrogance. The arrogance that says, other people
> may fuck up, it may be in their natures, but that isn't me. I
> am not one of those people who fucks up.
> And of course you are. We are. I am.

H: Charles was sixty-six years old.
 He was sixty-six years old and he had two sons.
 He had sixty-six years, two sons and cancer of the

oesophagus.

The thing about cancer of the oesophagus is you usually don't know you've got it until it's too late.

Charles didn't want to die, people don't want to die, mainly. But he'd got to the stage where he knew that there wasn't much more living to get through and when he could think about that,

when his brain could grasp that through gaps in the fog – he seemed to be OK with it.

He was in a hospital, and it was. Well, it was fucking grim. Not the nurses or the doctors, the institution. Hospitals are great for being born in.

But they're a fucking shit place to die.

Things take time to get done.

Which is a problem when the water's running out of the holes faster than you can pour it back into the bucket.

His two sons threatened to kidnap him. They told the hospital what they were going to do. They said, tomorrow, at 9 a.m., we're going to take him away. They were very polite about it.

'We really appreciate all that you are doing for him, but if this isn't sorted tomorrow then we will take him away and he will die at home with us because it's been two weeks and a general ward isn't any place for a man dying.'

And that night, someone somewhere else died, or maybe the hospital just got their arses in gear. But a hospice bed became available.

One of the closest things you can get to Heaven on Earth is decent pain relief and a room with a view of the garden.

People came to visit him in the hospice.

They brought in his stereo, and his guitar.

He couldn't play his guitar anymore, but one of his sons could.

They busted him out once or twice to push him round the garden to see trees and air and all the other things that are just too big to fit inside a room.

The eldest son was particularly impressed that the hospice had a smoking room.

He liked to go and sit in there whenever he needed a break

from his dad.

His dad never smoked, but his son did.

He smoked like it was an antidote to dying.

Sometimes, you can kid yourself, that the flat bit of path
you've just reached is going to continue forever.

And it won't.

But there was a week, maybe ten days, when Charles was
comfortable,

when he gestured for the TV to be turned on, when he
couldn't talk. When it was just him and his two sons, and
their mum, Charles's ex-wife, who was still close,
and the only sound in the room was someone finger-picking
the opening chords to 'Goodbye Yellow Brick Road' on an
old nylon-strung guitar.

Soon though, there were injections and catheters and gaps
in the breathing when everything hung. The body rejecting
food, and itself, and spasms when Charles seemed to be
having one last attempt to wrench the cancer out. It was
almost like there were two organisms on the bed. One of
them, slowly and surely squeezing the last drops of life out of
both.

They put him on something called the end-of-life plan. The
beautiful nurses whose job it is to see people out of the world,
over and over again, had seen it all before. When he wants to
go, we let him go. That's the end-of-life plan.

Charles was a believer, his sons weren't, but that didn't
matter.

An old vicar friend of Charles's came to see him.

He spoke to Charles and reassured him – that no, this wasn't
a punishment,

that God, above all, wanted Charles to be without pain.

At least that's what his son imagined he said.

CHRIS interrupts here suddenly.

C: I had to imagine what the vicar said, because I was actually
 down the hall while he was in there. I was smoking with two
 final-stage lung cancer patients. I came back in and sat with
 him for a while after the vicar had gone. I sat there and I

played the guitar and I wrote some stuff down. My brother turned up. And we held his hands with his eyes half open, and we sat there as poison and piss drained out of him into a bag by the bed and we said. I won't go through it all, but what we said was hey Dad, you did good. You did fucking good and we're proud of you, because you had a fucking hard life, and you somehow managed to get through it, and do some good, and make a lot of people happy. And we wouldn't be here without you, and we're proud of you.

My brother went home. He had work in the morning. I stayed. About 2 a.m. I went for a smoke and to find a cup of tea. I stuck my head into the nurses' station to say hi. And the nurse on duty, Angela, said why don't you get your head down? He's not going to go tonight. He'll make it through til the morning. There's a sofa in the family room. So I did. I got my head down. I had to get up a couple of times because there was a woman in the next room, screaming.

When I found him the next morning, I'd missed him going by minutes. He was still warm. I stood there beside him. And all I could think was. Oh fuck. All these months and neither me nor John were there for the last bit. He did the last bit on his own. And it wasn't that either of us had made a promise, or even that he'd asked us to be there. It's just, who wouldn't want to be there for the last moments of the life of someone you loved? Who would want that person to be on their own if there was an alternative?

And I've made my peace with that, I think, I think I'm good with that. But there it was. Oh fuck. Last hurdle, and somehow. I let him down.

H: Some oh fuck moments are stone silent
 they don't break the sound barrier before they meet the sea,
 and this one was a man standing in a doorway
 half-asleep, realising he'd missed it.

C: Some grind through history,
 an iceberg and a ship's hull, keyed open like a sardine can,
 a song of sinking, a lament for lifeboats, decency and
 mathematics.

H: Some glass out from atoms,
a chain of fission, elements, alive, then not alive,
in a flash that fixes flesh to buildings.

C: Some are lost in the cacophony,
a toy boat keystroke, swept away in data, resurfacing years later
when economic theory makes us homeless.

H: Some oh fuck moments are spot lit and singular,
a phone box ringing on a motorway bridge.
They don't change continents, shift ships, save Adam,
they're two lids shuttering
a tree falling on a philosopher, a pin we carry in a tin box
and secretly, we sometimes prick our fingers.

C: Some oh fuck moments happen when there's no one else around.
The thing with my dad, it was a quiet thing, internal.
It wasn't a chain of errors that ended in a smoking hole
in the ground, or a miscalculation that brought a banking
conglomerate to its knees.
It was a moment that was missed.
Nobody else there.
No global consequences.
Just something that happened a certain way and you can
never go back to.

And then there are the oh fuck moments where a hole in the
universe opens up and swallows us in public.
Mostly, these oh fuck moments happen at work, and
usually the oh fuck feeling is out of all proportion to the
consequences.

H: Let's go back to the office.
Let's go back to profit.
Let's go back to customer service and brand identity and
professionalism.

C: Because these things are holy, apparently.
They cannot be sullied by mistakes, and in most of the
environments that people work in, if you violate the
behaviour they require,

H: even by accident

C: you're like a priest who broke into the Vatican and took a shit
 in the Pope's hat.

H: Our CVs say things like motivated, efficient, a team player.
 When they should say. You know, I get tired and depressed
 sometimes and I feel like more work would equal death.

C: I once atomised the accounts department with an extra zero.

H: Or sometimes I call people cunts.

C: And we're not saying that any of that is desirable behaviour.
 Especially the last one. But it is human behaviour.
 Weirdly, some quirk of our development has convinced us
 that mistakes are as eradicable as smallpox. We've made a
 category error – we've put them in the box of optional things
 instead of the box of reasons that we're here at all.

H: They don't fit with our idea of how we want to be,
 or more importantly how we are wanted to be.
 They rub dirt on the aesthetic.
 On neat rows of work stations and spotless walls,

C: on the idea that you can buy someone's time on this planet so
 completely that someone else can dictate it to the second.
 And we punish mistakes and so making a mistake
 results in an unnecessary oh fuck moment:

H: 'I forgot to back up the server overnight'

C: and that sparked the horror of danger,
 and the fear of death,
 of the shadow of the tiger in the forest.

H: These days the tiger in the forest is squatting in our inbox.

C: Remember the pilots from earlier?
 The aviation industry's got it right. They don't blame. They
 learn.

H: Yeah but we don't do what the aviation industry does.
 We don't have conferences of great mistakes. We punish
 them.

C: And that fear of punishment makes us into secret-keepers.
 And we put up pointless warning signs and never the ones
 we should.

C: In the case of fire, do not have sex in this lift.

H: Do not use your lanyard as a noose. Even when jesting.

C: Do not scratch your eczema over the biscuit tin.

H: The CCTV in the toilets, is not an invitation to a display of
 piss athletics.

C: Do not smoke near the accounts marked flammable,
 unless you have been expressly told to do so.

H: Danger, high voltage, does not recharge your iPhone super
 quickly,
 The spillage in the foyer is not an ice rink –

C: do not hold up cards marking falls out of 10.

C: Please do not stand on office swivel chairs.

C & H: Just don't.

H: In the interests of hygiene, please wash your hands,
 mind the step, keep the fire door shut,
 do not run your genitals under the tap that says caution, very
 hot water.

C: Do not photocopy the stairs.
 Do not do monkey impressions from the fire door panic bar.

H: In fact do not touch the panic bar.

C: Do not even think about touching the panic bar.

H: Do not use social media to give the manager your diagnosis.

C: And do not put your fingers in the water cooler to wind up
 the piranhas.

H: Above all, do not ignore these warnings.

C: When shooting stray dogs at the abandoned nuclear plant
 Do not pick up pebbles to take home as souvenirs.

They may be contaminated with radioactive material
And therefore dangerous to you and your family.

H: This automobile is not designed for certain pastimes.
It is not safe to attempt fellatio while driving.
Impacts sustained at speed during oro-genital activity.
May cause sudden amputation of the penis.

C: These are the warning signs we should have made
For the oh fuck moments we had not imagined
Some things we never know until they happen
But second-guessing them would mean more sign than
planet.

H: Our whole world is held together by the construct of
competency and we risk assess, data protect and evaluate for
error.

C: To admit you fucked up is like putting a bullet in a gun
and handing it to the person who wrote the competency
framework. The framework itself is a sign of being afraid, it
says, 'I'm too scared to admit I might let the chaos in.'

H: True story. They found Alvin, dead, in his apartment.
When I say 'they' found Alvin dead, I'm referring to the
emergency services. Specifically the ambulance crew that had
been called there. So we've got a dead guy, in his apartment,
and an ambulance crew.
After they'd worked back from Alvin's grey and lifeless body,
winding back the trail of up-ended furniture, bloody hand
prints and agony to the point where his oh fuck moment must
have occurred, this is what is most likely to have happened.

C: Alvin had a thing. And on the day Alvin died, the thing had
obviously gone horribly wrong. They found Alvin's body in
the kitchen, by the phone. He'd bled to death. Specifically
he'd bled to death through what was later called 'localised
tearing in the colo-rectal membrane'. Which basically means
all the blood in Alvin's body had slowly seeped out of him
through his arse.
The thing is, this needn't have happened to Alvin. The blood
hadn't left his body in a huge gush, he hadn't severed the
carotid artery on his neck or the femoral artery at the junction

of his leg and his body. If you do either of those things, you can be dead in three minutes.

Working backwards from the kitchen, however, it was apparent that before making that final phone call Alvin had been bleeding fairly slowly, but consistently, for at least two hours. The sensitive membranes in the inner surface of the colon are slow to heal, so they'll carry on bleeding for a long time without the blood clotting. They're a problematic place to sustain a tear or laceration, but it's not immediately fatal.

H: Alvin had apparently walked from the bathroom, into the living room.

There were bloody hand prints on the bathroom door frame and on the magnolia print wall.

The hand prints weren't streaked,

and were consistent with constant, calm pressure.

There was a blood-stained depression on an old towel on Alvin's couch.

The TV was on.

Alvin had obviously sat down to watch daytime TV until the pain and weakness became too much to ignore, at which point he had staggered into the kitchen, and made the phone call that turned out, tragically, to be too late.

In the bathroom, the police, found an old hockey stick made from a single piece of wood, with a smooth handle. The handle had a rounded end.

The handle of the hockey stick was streaked with blood, and what was later analysed as trace amounts of faecal matter. There wasn't a lot of blood, but it was streaked quite far down the handle,

about a foot, according to the incident report.

CHRIS gets up, picks up the hockey stick and sits back down with it resting in his hand.

C: What had happened, most likely, is that Alvin was masturbating. Standing at the bathroom sink. And in order to give himself an extra level of stimulation he had inserted, quite gently I imagine, the rounded end of the hockey stick's handle up his arse. Then he'd braced the other end, the blade of the hockey stick, sideways against the bottom edge

of the bath panel where it met the floor. This was probably so he could lean back, while he was masturbating, and vary the pressure of the handle of the hockey stick where it was inserted into his rectum, in order to enhance the level of pleasure he was receiving. And it looks like the hockey stick, precariously balanced on its thin blade in the right angle between the floor and the bath panel, slid out of position just as Alvin was leaning back on it slightly harder than usual. And that Alvin fell backwards, with the stick catching on an uneven floorboard and arresting its slide for a second, plunging the handle of the stick suddenly and not-too-gently up Alvin's arse, where it tore a hole in the mucous membranes of his rectum and lower colon and their associated blood vessels through which Alvin slowly bled out of this life over the next two hours. Oh fuck.

H: After that the rest of the apartment kind of explains itself. Alvin pulls out the hockey stick and throws it into the bath. He stands in the doorway to the living room, taking one hand away from the site of the injury to support himself, and then he sits down on the couch to subdue panic and fear

C: with a little of what the estimated timeline of events suggests might have been a re-run of *The A-Team*. Alvin puts off phoning for help out of fear of embarrassment, and by the time his realisation of how serious the situation is has overcome his reluctance to ask for help, Alvin is dead. Despite that fact that any paramedic with more than a week or two on the job will have seen stranger things than a man who simply enjoys putting a hockey stick up his arse while he masturbates.
Alvin died. Because he let his oh fuck moment kill him. What is it that stops us coming forward? In Alvin's case it was embarrassment, but underneath that is a common factor. When we fuck up, we worry about how it is going to look and we beat ourselves up over it. And I guess that shame's useful, because it's unpleasant, and we'll try not to feel it again. But if we can't get past the shame and the desire to repeatedly punch yourself in the face, it just becomes a form of arrogance.
The arrogance that says, other people may fuck up, it may be

in their natures, but that isn't me. I am not one of those people who fucks up

H: and of course you are. We are. I am.

C: It doesn't start, though, at the moment you decide to put a hockey stick up your arse. It starts way before that.

H: We don't teach children that we live in a state of chaos.
We teach them routines and right and wrong responses,
and we are educated to be afraid of being wrong,
we don't know how to handle our mistakes.
We are fucking terrified of putting our hand up and admitting it was us.
You can't cover this one up. Someone is going to have to be told.
Because even if you kept quiet.
Even if you ran away.
Someone's going to find out, so you think pretty fast.
You think, a bit, in crap haiku:

C: Darren fell off the garage roof at the back of the flats
trying to get the Frisbee back,
and now the bone's sticking out of his arm
and it would be nice if he was moving a bit more.
I was just interviewed on TV
about New York's day of terror
the one a few years ago, when planes burst through buildings
like Godzilla's claws
And I saw the end of Darren's bones again,
because I am grown up now,
I am expert
and on live TV, I called that day, 7/11.
And now my balls feel funny.

C: We learn that we live in order and mistakes let chaos in. Rather than the reality. The reverse. Everything is chaos. Any order we get, that's just a bonus.

H: Groups of people have always told stories of disaster to avoid disaster but they've kind of mutated from their original function.

C: Way back when, you turned the corner,
you saw the sabre-toothed tiger, you saw the tiger's teeth.

And that dead drop, the realisation that fight or flight is out of
the question,
the feeling we got as the tiger leapt, is the same feeling we get
now, when we send that email, or break that precious thing,
or betray that lover with a look.
Except, back then the tiger ate us.
Most of the time, now, we have to go on living.

C: We are accelerated primates, bones splint by our own speed,
our reflexes artillery, even in peace.
We have elevated evolution, traded races, mapped mountains
called for plastics, carpets, bricks, embarrassed by the camp
fire.
But folded in the nucleus fifty thousand years of instinct, we
shoulder them in sleep, ancestors shouting instructions from
cave pits.

H: The wild things want your epiglottis, eyelids, perineum,
cornered on the cliff, heel at the edge of the abyss,
watching the grasses split for plain winds, insects, the
whiskers of planets,
the knowledge you should never tangle with a sabre-tooth
kicks in,
your gut reflex, messenger to cortex, this is the death bit.

C: That antique bunsen says give me your wrist, hold it here,
steady
learn this, remember the skin blistering,
and we do not hold the stick by the burning end in darkness,
do not put the King in frontline of battle,
do not prescribe un-tested medicines to pregnant women.

H: And we learned these, but the borderland
between intelligence and instinct is split,
leaking brain fluid into skull cavities,
and where there were tigers,
now there are spreadsheets.

C: Our ancestors are heavy-handed siblings,
we pretend we aren't related, but they turn up to the party
uninvited

H: saying remember we used to shit ourselves at tigers, pushing
the same panic when documents vanish.
This paradox, of never more solo,
you on a cliff top of error and office,

C: still as a reflex, a shout from the cave pit
you and your ancestors, pulling at chain links.

H: You'll never feel more alone than in the moment you fuck up.
But actually, you'll never be more connected,
more genetically linked in to all your ancestors,
standing behind you, the apex of a great fleshy triangle,
nodding their heads and saying yeah, I know that feeling,
whether you put a cat in a wheelie bin or botched the design
for a nuclear reactor
or crashed a plane.

C: Fortunately, none of you have done any of those things, or I
hope not. But some of you will have a big spot, under your
mugs.
Push your mug forward if you have one of those.
First off, are you all OK reading your oh fuck moments out?
This next poem is a poem for all of us.
This is a poem to say, let's celebrate, let's hold our hands up,
let's do something useful with all that energy that we could
use to beat ourselves up. During the poem, Hannah will nod
at each of you in turn, all you need to do, is read your post-it
note.

H: Construct monuments. Make them our faces.
Cut us in granite at the moment the penny dropped. And
underneath, carve:
'WE ARE THE PRESIDENTS OF THE UNITED FUCK
UPS OF EVERYTHING.'
Commission artisans to memorialise our tiny accidents
in chrome and alabaster, lest we forget.
'This is where she neglected to hold her daughter's hand at
the top of the steps', and later
'This is where he made his life into a lie.'
Close the roads,
make *(insert the date and day and month that the show is taking*

place on) a day of remembrance,
then let it slip by unmarked as a lover's birthday.
Let's have a family party
where fuck ups are piñatas
but we don't smash them, we carry them,
shoulder-high birds of paradise.
Choose an anthem, let the first line be:
Into a bench, hack: *(audience ofm)*
On your bedroom wall, hang: *(audience ofm)*
In school assembly, teach your kids to chant: *(audience ofm)*
In an antique locket woven from your grandma's hair:
(audience ofm)
Tattoo your forehead in jaunty comic sans: *(audience ofm)*
Document all this, send for the museum service,
ask for tips in statue-maintenance.
Organise a pilgrimage of disasters
and when the message spreads
and thousands gather, unashamed
to touch the stone hems of our great mistakes,
we'll know the human race has finally accepted
that we are messy, structurally inept
and states of grace are dreams that hold us static.
In thirty-foot bronze letters, hung over the crowd
we'll hang our welcome message
'Thanks to those of you who taught us most
by fucking up the worst.'
And when the knots come loose, and the letters
like guillotines, putt the statues' heads
into the crowd, we'll applaud it.
Because the carnage kind of proves our point.

C: No one's going to build a statue of Alvin with a hockey stick
up his arse, or me standing in a hospital doorway or Hannah
writing an email about a horse.
And if they did the statues will probably fall down, but
maybe the stories would carry, and the mistake wouldn't
happen twice.

Why do we get so ashamed? You might feel like it ruins a
run of perfect performances, but hey, that was going to end
anyway. It really was. And whether you piss up a spreadsheet

or fail to avoid an iceberg just depends on where life's put you when it's finally, unavoidably, your turn.

And it's not that there's no difference between getting it wrong and getting it right. It's just that fucking up – properly, humanly fucking up – is still a lurch in the right general direction.

Some oh fuck moments are uncontrolled explosions. They end lives, or wreck lives. We're not saying that's OK. But let's take them out of the cabinet, re-sort them, keep them in the file marked 'live'. Let's learn the lessons that people died to teach us.

And those other oh fuck moments. The evolutionary reactions when we break some arbitrary framework or reveal our humanity in an office cock-up, well our reaction to those comes from some time in our past that we haven't out-evolved and we probably won't.

So let's be glad that they're part of us.

Let's not make them make us scared of ourselves or each other.

Because we're not perfect beings who fuck up.

Actually, we're fuck-ups. Who, very occasionally, achieve perfection.

Last poem?

H: Last poem

C: A pilot's pocket catches on the autopilot switch,
 A surgeon dips for incision and slips.
 A mountain guide clocks the map upside-down
 and here is no water, only rock.
 A man slips in the bathroom and it goes all the way in.
 A gambler's ball scuttles back to black.
 A child falls off the roof out the back.
 A dendrologist hacks down the world's oldest tree.
 The facts had no back-up:
 And I am a fuck-up.
 Of course you are, we are, I am.

H: Take minutes while the mushroom clouds bloom in your eyelids,

The heat of armpits, the musk of primates,
stomach drop like a car off a bridge,
while the girl in the passenger seat fumbles the gear stick.
We are the apex of pyramids of ancestral 'I did this',
And each monkey admits, he is imperfect.
And of course you are, we are, I am.

C: The office is a safari of signage,
piranhas in water coolers, tigers in filing cabinets
anarchy in in-trays, foyers and contracts,
tectonic plates held steady with systems,
procedures against love and lust, volcanoes and weather,
you cannot throw stationery, lanyards,
spreadsheets down to feed chaos.
You think this is order, and you can control it,
and of course you do, we do, I do.

H: You little perfectionists, blinkered like thoroughbreds,
collapse the card house,
drip oil into the gulf like vinaigrette,
you economists singing on the edge of the abyss
do not know how to see the world as it isn't.
You cannot remember the past
and think the future will build monuments.
And it won't, we won't, I won't.

C: So we sit, with Cheshire pub-table grins
savouring failures like ash-less cigars.
Instead of 'and that's why you shouldn't eat those berries,'
it's, 'and that's why I am glad I am not him.'

H: But we tell these things, because we can imagine,
what it's like to be someone else, in some other place
standing in a doorway, an outline of grace,
realising there is no such thing as death and glory. Just death.

C: The ghosts of pilots spool from black boxes,
there is still disaster, health and safety heretics
battling God complexes, a small series of arm movements
leading to a smoking hole in the skin of a city,
and an attempt to jigsaw lessons from 'I'm sorry',
and of course you are. We are. I am.

H: We are standing on the shoulders of our great mistakes
 and we should celebrate, in stadiums,
 our faces radiant with permanent marker
 our foreheads beaming messages
 of the moment we realised which switch we just flipped
 the ice beneath our feet cracking into continents
 and written on us in a hopeful epitaph
 there is no way back,

C: but the future will forgive.'

H: And of course it will.

C: We will. I will.

CHRIS and HANNAH thank the audience and say 'if you want to take your oh fuck moment away and destroy it, feel free. But if you want to, leave it here with us, it will travel round with us as part of the show.'

I WISH I WAS LONELY

The audience gather in the foyer.
The venue staff distribute blank postcards and pens.
The audience write their mobile numbers (no names) on the postcards.
If an audience member does not have a mobile they write 'no mobile'
and their initials.

HANNAH and CHRIS open the doors and invite the audience into the space.
There are forty chairs in the space, all placed at different angles.

As the audience come in, HANNAH and/or CHRIS collect their postcards and
ask them to sit in one of the chairs.

When the audience are sitting, HANNAH and CHRIS come together, and in
full view they split the deck of postcards in half and shuffle them.
CHRIS types one of the numbers into his phone.
Taking half the deck each, they distribute the cards, one to each audience
member, during the opening poem.

C: – If You have Equipment which enables you to access the
 Portal,
 this section applies to You.
 You are the Consumer –
 a real person
 entering into the Agreement.
 This Agreement starts when We decide.

H: – We will always try to make the Services available to You
 but sometimes,
 with regret,
 the Weather, Faults and
 the Arctic-bound tracks of high-flying birds
 may shimmer unhelpfully, or
 the heart of Another may just
 not Be In It.

C: – But we will make all Efforts to Empathise.
 For strongest connection, make sure
 you are in range of a Base Station
 and sometimes,
 in the absence of a Station
 your approximate Location may be provided
 to the Emergency Services.

H: – We will make the bill for Your Monthly Account available
to You
every month, by a method of Our choosing.
You may realise there are Other Bills
but these are not our Responsibility
and the Deficits incurred are Only
imposed by Yourself, on Yourself.

These can include penalties levied
for living in Two Worlds,
or Ignoring the Traffic.

C: – We do not recommend you Ignore the Traffic
and come to that, We
ask you to be mindful of Trees
and the Changing Seasons,
Other Users of the Planet may be real.

H: – You shall be required to pay a Deposit
if You refuse to pay this, or show Discomfort
or swipe Your Fingers reflexively across a person's eyes
the liability is all yours.

C: – You have a right to ask for a copy
of Your Personal Information,
although this May not be an
accurate Reflection of your Personality.
If You rely on the Categories of Personal Information we
provide
as a Sole Tool for Assessment of Your Self
you May Provide an Unsatisfactory
end User experience for Others.

H: – You are Responsible for
anything you may

C: – Upload,

H: – Email,

C: – Vocalise

H: – or otherwise Transmit.

C: – You are Responsible.

H: – You are Entirely and Wholly Responsible.

C: – Reminding You Of This

BOTH: – Is Not Our Job.

H & C: – Hello.

C: – Before we go on.
 Has anyone got the card with their own mobile number on it?

*If anyone says yes, HANNAH and CHRIS make sure nobody is holding
their own number.*

C: – Could you make sure your phone is switched on please.
 And could you make sure it is set to ring, not on silent.

H: – Before we go on, we'd like to ask you a question. Just out of
 curiosity. How many people do you think there are here? (x).
 If, right now, I was to take your mobile phones from you, and
 during the next hour or so, one of those phones was going to
 be wiped of all its data – so you'd have a one in (x) chance of
 losing all the data on your phone – put your hand up if you'd
 leave.

 So that's (y) people. Thanks.

 Obviously we're not going to do that. We want you to trust us.
 If we did do that, it would be at the very least an abuse of your
 privacy.
 Almost of your personality. So if you're worried, don't be.

C: – In your hand is a mobile number, assuming everyone wrote
 down their actual mobile number, it's the number of someone
 in this room. Could you pick up your phone and type that
 number in now please.
 Don't call it.
 But be ready to.

47

H:　　　– Now this is a bit of an experiment,
　　　　if we don't get the timing right, don't worry,
　　　　you are not going to break the show.
　　　　I'm going to say 'go'
　　　　and when you hear 'go,'
　　　　call the number you just put into your phone, let it go to
　　　　voicemail.
　　　　If doesn't go to voicemail straight away, wait until it does.
　　　　If it doesn't go to voicemail at all, no problem.

　　　　But if you get through, leave the person a message,
　　　　Tell them your name, tell them why you need your mobile.
　　　　Say, Hello my name is... I need my mobile because...

C:　　　– You could tell them why you need your mobile by giving
　　　　a specific example from your life, or you could tell them a
　　　　sentence or two.
　　　　This might be cacophonous and confusing and that's alright.

H:　　　– I am going to say, 'go' and when you hear me say that, call
　　　　the number you just put into your phone.
　　　　Ok, go.

The audience make their calls.

C:　　　– Could you put your phone down on the floor, in the box
　　　　that's drawn in front of your chair?

*The audience place their mobiles down into a phone-sized chalk
outline on the floor in front of their chair.*

　　　　Your phone might ring in the next hour and a bit.
　　　　That's fine.

　　　　If your phone rings – you can answer it. In fact, we'd like you
　　　　to.

H:　　　– If you choose to answer, please have the conversation you'd
　　　　normally have.

C:　　　– Because we'd really like to hear it.

*During the previous lines, CHRIS has called the number he typed in
earlier. An audience member's phone rings. They have a conversation.*

The conversation is based around the following theme but it could go anywhere.

(Asking for your mobile number is more personal than asking your name.
For all we know, there are four people in this room right now called Luke, or Rachel.
But that number is you.
The system wouldn't work otherwise.)

H: – That was easy, wasn't it?
 As for texting, tweeting, all that, feel free.
 Your phones are on.

C: – We have entered a new era –
 globally connected, instantly accessible
 we are living in the future and we love it.

H: – But there's another point of view – the future is suffocating.
 It's like we're suddenly trying to breathe helium.
 We're the victims of technological changes so rapid we
 don't see that electromagnetic spike
 until it's been driven into our cortex.

C: – When they invented the steam train, there were people
 who said our heads would fall off, if we travelled at over 30
 miles an hour.
 And that's fear of progress.
 And we're not saying progress is bad.

H: – Because, Chris and me, we use this technology.

C: – We're calling,
 we're calling you
 through waves and wires from fibre optic hearts.

H: – We are just calling to say

C: – we are just calling to say

H: – we miss you.

C: – Not waving but in constant metaphor,

H: – The drains brimming red with information:

49

C: – texts of conquests,

H: – Instagrams of gourmet burgers,

C: – public reports of hangovers,

H: – quotes from the family dog.

C: – We've gone too far, and we admit

H: – we are little gods doing monologues,
 atomised in crowds, familiars in pockets,

C: – and alone is not the same as lonely.
 We are moving at such great speeds
 and we don't have time to think,
 the wires overspill the brain socket,
 and this is just how we do things.

H: – Chris, you text whilst maintaining conversations,
 have learned to shit whilst wishing your mother happy
 birthday,
 imagine if you did that at her party.

C: – At least I answer, even when I don't want to,
 you force me to imagine the smirk as you muffle my call in
 your overpriced fashion satchel.

H: – Well, don't phone me so fucking often then.
 We haven't asked you here to smash your thumbs with
 hammers,
 Or, tell you, life is better lived in a lead-lined room

C: – but sometimes we miss you
 and you're always in our pockets.
 And I at least admit, most of my sweetest words these days
 get bounced off satellites or slung from tower to tower on
 waves
 and if they weren't, my absence from my own life
 would make my heart impossible.

H: – But me, I dream destruction of this little bastard box,
 death by river, death by rail, death by arcing rock.
 And I would glisten solitary on the edge of landscapes,
 a single iron filing on an expanse of white tablecloth.

C: – And if it wasn't for the forty-nine voicemails that you will
 never listen to
 I know you'd atomise the fucker in a second,
 but you won't.

H: – I never feel like I am on my own.
 And I never think about if I have a choice in that anymore.

C: – The other day I was standing at a bar, waiting for a cup of tea,
 and I reflexively put my hand into my pocket to look for my
 phone. And I didn't have it.
 I felt like I'd left a part of my body on the table in the other
 room.
 And for a moment I felt lost and amputated.
 If you call me and I choose not to answer, .
 the world makes me feel like I am failing at my own personality.

H: – On the other hand – couple reunited after 50 years apart
 surgeon saves life of boy in Congo via text message instructions

C: – I made it to the pub in time to wish you Happy Birthday.

H: – Yes. You did.

C: – We harvest the energy of stars
 for business, for pleasure, for life.

H: – The future's bright, it's everywhere you want to be.
 Swipe the edges of galaxies with finger tips.
 You are free to live in three dimensions

C: – for the first time,

H: – your life, your voice, your choice,

C: – get more, power to you.

H: – Extend yourself, unfurl networks,
 quietly brilliant intuitions.

C: – Your device, your life, your world,
 your mountain top to claim.

H: – Believe in something better
 you will never be alone

C: – you will always be heard

H: – use yourself

C: – put people first

H: – make things work the way you expect them to

C: – see the world the way it was intended.

H: – We are you.

C: – We've come a long way, life's good.

C: – But we are always handcuffed to the network.
 We've been sold each other.

H: – And we are bound by that contract now.
 The branding was brilliant,
 if you don't participate, stop existing.

H: – For the lonely alcoholics in budget hotels,
 drafting texts, refilling kettles,
 pressing send, requesting FaceTime from the dead.

C: – For the ex-wife raising her wrist to her cheek
 to check for messages from other time zones,
 toasting the past, unclogging the swimming pool grate.

H: – For the father in the spare bedroom
 that used to not be spare,
 clacking search engines, listening for echoes of his daughter.

C: – For the girl casting nets at her own name,
 waits half hope, half dread of mention,
 evidence enough of friends.

H: – For the couples updating at the desert of the kitchen counter
 wine glasses and the slow dead rise of silence,
 as they look at their laps, avoid eye contact.

H: – For the siblings who can't talk about Dad
 playing poker, scanning spam, unsubscribing updates,
 posting clips of *Ghostbusters* to Facebook.

C: – For the mother on forums,
 fretting nights, nursing threads, trading scores –
 picking at scabs of should do.

 Little pets with crowns and sceptres
 bathing in the constant-ness of now,
 the ever-arching halo of update
 keeping us static.

 In the past people didn't have this option.
 What if Alexander Fleming had had a mobile
 and called back to the lab to say,
 'Hey, I left some petri dishes on the window sill,
 could you please clean them up.' That's penicillin dumped
 down the sink.

H: – Rosa Parks standing at the bus stop
 tweets to say – I don't want to give my seat up for some white
 man today.
 Tweeting gives her external validation for her feelings,
 and it makes her feel better.
 So she sits at the back of the bus in the coloured section
 and does not act on what she knows is wrong.

C: – Look at Egypt.
 Mobile phones are a brilliant way of telling people the protest
 is happening.
 You can overthrow your government with Facebook.
 But after the change, there will still be people with dangerous
 opinions waiting in the wings.

H: – And if you like someone else's revolution on Facebook,
 They can still get shot
 Every single person who clicks feels they're part of solving a
 problem.

C: – But you don't live in Cairo.

H: – Assad did not read your retweet.

C: – And you are not Trayvon Martin.

H: – It's just an active form of inaction.

C: – We crowd source our values.

H: – We have strip mined ourselves.
 We do not feel like we need to be on our own, and we do.
 It's important that we have opinions,
 that we decide what matters to us, before we express it.
 Imagine our aloneness is calcium,
 that Polyfilla keeping our bones bound,
 that our aloneness forms who we are like calcium forms our
 bones.

C: – And then imagine some sleek-fingered company came and
 offered to buy
 all the calcium in our skeletons.

H: – Hopefully, our collective response would be,

C: – fuck off, that's ridiculous.

H: – But when they came for aloneness,
 we threw our arms wide and said, YES.
 Of course I want to tweet,

C: – of course I want to tell everyone what my favourite
 Metallica album is,

H: – of course I want to carry with me hundreds and hundreds
 of numbers and names who I can contact at any time or
 place,

C: – of course I want to be with you and by you and near you
 every single minute of every single day,

H: – of course I want to gather all my friends and family and
 associates
 into one place and scream, 'do you like my fucking hair?'.

C: – And of course they want to have an opinion on that.

C: – Of course I don't need my sense of self,

H: – who wants to be alone?

C: – who the hell wants to be on their own?
 Why haven't we said no?

H: – Could you stand up and put your chairs in a circle?
 Could you place your phones in this circle in the middle of
 the floor please?

The audience move their chairs into a circle.

The audience place their mobile phone in the middle of the circle.

*CHRIS pretends to take one of their mobile phones, but actually has a
dummy phone.*
HANNAH goes outside the circle of chairs.
CHRIS stands in the middle

H: – Imagine for a moment that it all stopped.
 That we turned off the cloud and the satellites fell out the sky,
 we dredged up and cut the undersea cables.
 Then your phone is a useless brick of dead circuits.

 What parts of your mind would be deleted?
 How do I find everyone?
 I am not asking that question metaphorically, actually, how
 do I find you?

*At the end of each of the following lines, CHRIS stamps on the dummy
phone, breaking it.*

 How do I get out of this conversation now without switching
 you off? *STAMP*
 Why is there nothing in this room to entertain me? *STAMP*
 Why do I assess the things people say by how good a tweet it
 would make? *STAMP*
 When is the last time I looked at a sunset without taking a
 photo of it? *STAMP*
 Why can't I sit in a pub on my own without texting? *STAMP*
 Is that my phone that Chris is stamping on? *STAMP*

 We know it feels wrong, we can see the signifiers.
 When we are sitting at a table with someone we care about,
 and we are deep in conversation and their eye flicks down
 to the phone lying on the table, it breaks our hearts a little.

 But maybe our communication systems are just too big and
 authoritative to fail.

Like Merryl Lynch was or Lehman Brothers.
But then, we all used the banking system and it turns out we didn't have the
first fucking clue what that was doing to us either.

We are fucked if it all gets turned off.
We're not used to the reality and mess of people.
We've learnt to filter each other.

HANNAH and CHRIS go to opposite sides of the stage where there are two mics set up. The next section into the mics, deadpan.

C: – Do you like what we talked about doing last night? To each other?

H: – Yeah. I loved it. I loved what we talked about doing last night.

C: – I've been thinking about it all day. I've been listening to this…

H: – I haven't heard that before. That's awesome.

C: – It's off their first album. You should torrent it. It's a fucking great album.
 It reminds me of you.

H: – Do you miss me?

C: – Yeah. I miss you.

H: – When are you back home?

C: – I get back to town on Tuesday night, late.

H: – Great. There's a gig on Wednesday. This Japanese band. Want to go?

C: – How about I come round on Tuesday when I get back.

H: – I might be tired.

C: – That's OK.

 Pause.

H: – Where did you go this morning?

56

C: – Had to work. I didn't want to wake you.

H: – We didn't do the thing we talked about.

C: – That's OK. I was as tired as you were.

H: – We should do it soon.

C: – Tonight.

H: – Sure.

Pause.

C: – I miss you already.

H: – You too.

C: – I just wanted to say that.

H: – You could have said that last night. You've left again now.

C: – I didn't miss you last night.

H: – You didn't say much either.

C: – I'm saying it now.

H: – I know. It's just not the same.

C: – I did say it.

H: – You just looked at me. You barely touched me.

C: – We had sex.

H: – We had something.

C: – I could see you didn't really want to do it.

H: – I did.

C: – It's easy to say that now.

H: – I said it last night.

C: – That wasn't really saying it though. You didn't say it with your eyes.

H: – What the fuck are you talking about.

C: – I wish you'd said it clearly.

H: – How could I have said it more clearly.

C: – Like this. I want to fuck you.

H: – I did use the word fuck.

C: – You didn't use it clearly. It's only when you write it down, that you say it like I want you to.

H: – I mean the same thing.

C: – No. When we're together there's something in the way.

H: – What?

Pause.

C: – I really like this picture. It makes me think of you.

H: – Good.

C: – I really like this picture. It makes me think of you. And how much I love you.

H: – Good.

C: – Do you love me?

H: – When are you back in town?

C: – Tuesday.

H: – We need to talk.

C: – We are talking.

H: – We'll talk then.

C: – We are talking.

Pause.

C: – I was just thinking how much I miss you.
 I was just thinking how much I miss you.
 I was just thinking how much I miss you.
 I miss you.
 I miss you

I miss you
I miss you

HANNAH holds up her phone – she plays the following text as an audio recording.

H: – We should miss people,
love makes us miss them,
our humanity makes us miss them.

But we never get far on the road of missing them,
before we have the chance to have a fix of them again.
And those kilobyte fixes of the people we miss
don't add up to a person.

They're stones thrown into the hole of them not being there
that will never fill it up.
It used to be that if someone wasn't there,
they just weren't there.
And when they came back,
you were happy to see them
because you'd noticed they were gone.
And if I can't miss you.
I can't love you.
Because you are not real.
It's missing you, that makes you real.
And if I can't do that properly,
Then I can't love you.

HANNAH tells a semi-improvised true story about her friend Sam, who she didn't know very well, calling her when he was standing on a cliff on the east coast, thinking of jumping.

At some point during this story, CHRIS calls the number of one of the audience members and has a conversation with the audience member, playing the part of Sam. No physical acting. Just talking. The conversation is improvised.

C: – Technology won't stop everyone jumping off cliffs.
Otherwise nobody would ever jump off cliffs these days, and
they still do.
The fact we can find another voice over distance, is a
wonderful thing.

It's not just wonderful. It's a kind of a miracle.

H: – We all know what it feels like to be lonely – and maybe
 sometimes we need that one voice.

C: – But there's a difference between being lonely and being
 alone.
 And there are so many voices out there. And that multitude
 of voices, that's the internet. And this is what we think the
 internet sounds like.

H: – We'd like you to say each line of this poem onto the person
 sitting next to you. Pass it around the circle. I'm not going to
 wait for one line to get all the way around the circle before I
 start the next one.

*Each line of this poem is passed around the circle until the poem has
finished.*

H: – It's easy to be dazzled by the mountain
 the most extraordinary thing in the world
 is this relentless festival of bigness.

 Treat your egg whites with respect
 two of my favourite women each just had a baby
 here is a video of the beach umbrellas

 and yes you are the centre of the Universe
 I want to say this to every single follower
 I am lit up like a Christmas tree right now,

 I am a zebra and you are a unicorn
 let's hang out every day for the rest of our lives
 Do not like this.

 I may have to evacuate the ranch,
 But I stay because I like it too much.
 Get out of Liverpool you cunt.

 Quoting Dawkins is obligatory.
 Your job carries great power and responsibility
 I am full of owls,
 Stop repeating this now.

H: – I know this next phrase is overused

C: – I know that I know nothing

H: – I know that I'm no longer lonely

C: – and this is my fault not yours
and your fault not mine.

H: – The other day Chris and me were on a train and there was
this woman having the most ridiculously long conversation.
About her friends, and her sex life. I mean the details of her
sex life.
And I wanted to put a sticker on her which said – not in a
mean way…
Maybe, you're over-sharing.
And maybe this is over-sharing too.
But it's relevant I suppose. It's a relevant thing to tell you.

In February on Valentine's Day I found out I was pregnant.
I had been told I probably would not have children
and me and Oscar were really happy about it.
We bought a name book.
We talked about how we might make things work financially.
We moved cities to be nearer to my family so I could keep
writing.

It's a joke amongst my friends, well I say a joke,
but actually, it's a big problem, that I don't answer my mobile
phone.
I have, today, *HANNAH checks her phone* (z) un-listened-to
voicemail messages.
I find it difficult to talk on the phone.
I find it difficult to read the inflection of the other person's
voice.
I find it difficult to be in one place, food shopping maybe,
while finding out how they got on in their job interview or
how their mum is.
But I tour a lot. So I send a lot of text messages.

And the last day I was pregnant,
I was in the toilets of Addenbrooke's Hospital in Cambridge,
bleeding.
And I sent Oscar a text that said 'we have had a miscarriage.'

And I didn't think about him.
I did not think he might look up from a pint mid-
conversation
and feel the wrong kind of lonely.

Habit changes us. It changes our brains. The actual wiring
and the shape.
I forgot that he is more than an update.
That telling him through my phone is not the same thing as
telling him.

H: – You can walk through this place
a thousand cabled voices purring in your fist
and miss a Greek chorus of birds, the moon
turning from fact to impossible juggernaut.

C: – You can walk through this place
making a flick-book of minutes
and miss the slow waltzes of inconstant Russians
the underwater orchestra detuning till it sounds like… us.

C: – Your shadow is an archaeologist scrutinising brick and
braille
your shadow is a psychoanalyst sitting next to you on an
aeroplane

H: – Your shadow is a processing plant
mulching tomatoes and clowns and death.
You uninterrupted are an hour spent staring at the bracelet of
the ocean
wondering where the end is.

C: – The weight of your fingers on the end of your wrists is
mathematics
and also a room with just you in it.

H: – Do you ever let yourself feel lonely?
And if not, why not.
Who do you call to stop yourself getting too lonely?
I mean, who do you call most? When you're bored.
Think of that person.
Think of that person now.

C: – We know we love each other, right?
But let's say, for the next while,
when I'm not physically in your presence,
the only time I will call you is if I am on fire.
That is not a metaphor.
The only time I will call you on the phone, or text you,
is if I am actually on fire,
to tell you I am on fire.
And I want you to make the same promise to me.

H: – Not to say good night, or I love you.
Not to tell you about that video.
Not to check whether you prefer blueberries because I'm in the supermarket
or kill time because a bus was late
or because I feel an ache in my soul at the distance between us.

C: – I will only call you if I am on fire.
Actually on fire.

We would like you to pick up your phone from the middle of circle.
What we are going to do, is imagine that you are sending a message to the person
Hannah asked you to think of, that you contact most when you are bored.

H: – Take the card with the phone number on it that you had on your chair at the start.
And pass it round one person to your left.
Open a blank text message.
Type that new number in as the recipient.
Now in the body of the message type
'The only time I will call you is if…'

C: – Complete that however you want. It's going to be a line in the next poem.
It doesn't have to be, about disaster, like I will only call you if I am on fire.

H: – It could be something else entirely.
It could be 'the only time I will call you is if it's a full moon and it's impossibly beautiful.'

C: – So write your version of that.

Now send it to the number you have typed in, someone else in this room.

Who probably isn't the person you should send it to.

Now, go.

They all text their message to someone else in the room.

When all of the texts have been sent:

H: – The next poem is made of those texts.

Just hold up your phone up above your head with that message on the screen.

C: – Turn it to face behind you.

And we will see what we've got.

HANNAH and CHRIS move around the circle person to person reading the message from each of their phones.

Each line starts with

'I will only call you if…'

H: – Because then it will be real.

The real me calling the real you.

C: – Because of that ache in my soul at the distance between us

H: – Because I saw something only you would understand

C: – Because I needed to hear something only you could transmit.

H: – If every single one of the eight trillion text messages
sent around the world in the year,
was written on a single piece of paper,
the size and thickness of a bank note
and those pieces of paper were stacked one on top of the other,
not end to end,
but flattened out and placed one on top of the other,
that stack of paper would be

C: – 543,200 miles high.

Assuming it takes the average person,
ten minutes to walk a mile.

64

then to walk the equivalent length of that stack of all those
messages,
would take 5,432,000 minutes.
or 90533 hours and 20 minutes.
Or 538 weeks.

H: – Which is a little over ten years.
A little over ten years to go as far as all the text messages sent
in a year.
We want you to look at your phone.
Look at your address book.
Scroll through it.
Is there anyone about who you feel, this is a thin relationship?
You met at a party, you worked together for a few weeks,
you used to know their cousin.
It would have died a natural death if it wasn't for phones.
Delete as many as you want to in one minute

CHRIS times a minute.

C: – Keep scrolling.
Is there anyone who you just don't like anymore?
An ex, a boss, a service provider?
Delete as many as you want to in one minute

HANNAH times a minute.

H: – Is there anyone that's no use anymore?
The number is out of date,
you've never used it, you don't know what or who it is?
Delete as many as you want to in one minute

CHRIS times a minute.

C: – Next to you is a person, you might already have noticed.
And we are not in the habit of this kind of thing,

H: – but all we want you to do, in silence, is to look at the other
person.
Keep eye contact.
It doesn't matter if you laugh.
But we would like you to do it without speaking.

I'm going to time it.
2 minutes.
3,2,1, go.

In pairs and in silence the audience maintain eye contact for 2 minutes.
They stop when HANNAH's alarm goes off.

H: – That contact, the long conversations you have in bed
that time you said, this is the thing I actually mean.
Our fat thumbs, clumsy bats
sonar saying 'this is evidence, I exist'
signals so scatter shot it knocks planes from flight paths.
When the sales pitch comes
your clammy oyster ego will convince you,
you're too clever for the sell.

But you will covet.
Because it cuts out static,
makes you walk on water
renders love recordable.

C: – It will reflect, protect, edit –
fidelity, loyalty, friendship.

Use your magic boxes,
but do not forget,
(you will probably want to tweet this so do it)

Do not write overwrite the important bits.
Do not be a dick.
You spent 2 minutes iris to iris –
remember it.

H: – We are suspended from the belly of satellites,
sculling in space and chatter.
I am sorry but sometimes I will go silent,
because I want to belong to myself for a while.
I will move out of this instant city, charge reality real.
I won't wave to you from fields of mornings and mist
I will just be in them.

I will notice that the day after the storm,
everything was broken and it was amazing.
I will scoop up that tennis ball of interruption
smack it out of the stadium.

I will be alone
and the right kind of lonely

C: – One day soon…
One day soon…

One day soon, I will leave my house –
I will walk down the street. I will not take my phone out my
pocket to look at maps,
I will not text you to say what time I will be arriving.
I will look at things. I will think about the weather.
And who I am going to meet.
I will think about how I feel.

I might walk to the bus stop.
I might wait.
I might wait and think, and feel conspicuous.
I won't check my phone,
or take pictures of rain
or tweet lists of things I hate, today.

I will think about where I am going.
I will think about who I am going to meet.
I will think with my hands empty
and my mind loose as a pit bull in a park.

And when the bus arrives, I will get on it.
And I will sit by the window.

And I will feel like I am in a film.
And I will hope somebody notices.
And I might want to tell the world about this.

But I will look at the air and the people and empty spaces
between buildings
that aren't streets, or parks,
or things that contain the traces of the things
that used to be there,

and I will notice how I move through space and fact towards
you
and maybe I will try to imagine you. Or I won't.
Maybe I will think about you. Maybe I won't.

Maybe I will try to lead myself to an opinion without
checking what everyone else thinks first, even if it means I'm
operating without the facts.

Fuck the facts.

For this journey I will move towards you with empty hands
and a balloon containing a solar system. And I will almost
miss the stop but I will navigate by familiar sights, or if I am
in an unfamiliar city, by deduction, and guesswork, and trust.
And I will find a street, and a cafe, and I will be five minutes
late but I will let it go.
And there you will be, with nothing to look up from.
And I will say hello.
I will say hello.
And you will say hello.
And I will say hello.

And if it is awkward it won't be forever,
and if I don't like you, well that might change.
And we will pay attention to each other, even if we are both
a mess.

And if there is silence...

H: – Turn to the person who you just did the eye contact with.
And all we want you to do, and this is just a suggestion.
Is make an arrangement.
Arrange to meet for a cup of tea say.
Arrange a time, it can be this week,
or it can be on this date next year,
or any time you want.

The one thing is though, do not swap numbers.
It's an arrangement that you will keep or you won't.
But you have to remember it. You have to hold it in your
mind.

H: – For example: 6pm, May 16, 2014, Norwich Arts Centre café, Emma

H: – On the wall, by the door, there are two pieces of paper. There's a mobile number, Chris's mobile number, because he answers his texts. And there is a hashtag because I am more likely to respond on Twitter and you can have a conversation with each if you want.

C: – You can let us know if you met up. And you can let us know what that was like.

Technician fade up song, 'Harlem Roulette' by The Mountain Goats.

HANNAH and CHRIS leave.

Audience leave when they feel like it.

HANNAH and CHRIS do not meet them outside.

The door.